Watercolor Adventures

in Antarctica

Painting the Beauty of Nature: Landscapes & Wildlife

by an Expedition Guide

Author and Illustrator: Jiazi Liu

By Jiazi Liu

To my love Maurice, for all the happiness you bring to our life.
To Mommy, remember my dream of becoming an artist when I was five.
To Grandma, I know you are always there wherever you are.
To our cutie sweetie dog Lucky Van De Maele Liu, Wo,wowo~ wowo, Wo!

Contents

ACKNOWLEDGMENTS .. I

PREFACE .. II

INTRODUCTION .. III

I. PENGUINS .. 1

II. LANDING SITES .. 9

 Half Moon Island ... 11

 Orne Harbor ... 16

 Danco Island ... 19

 Cuverville Island .. 22

 Brown Station .. 25

 Damoy Point ... 27

 Whalers Bay (Deception Island) ... 31

III. OTHER WILDLIFE ... 36

 ABOUT THE AUTHOR .. 46

Acknowledgments

I appreciate all my family and friends who have always been supportive.

Special thanks to:

My husband Maurice Van De Maele Bello, this book would not be possible without you. Thank you, my dear, for listening and talking with me about all the aspects and offering me so many good ideas. Thank you for helping me with the drawings, the text, the designs, and the editing. More important, thank you for making me relax and laugh!

Professor Gao Dong, so grateful to have you, such an outstanding artist and an excellent instructor, to inspire me and help me with my painting all the time.

My dear friends Dr. Natalia Rosciano, Miguel Rodríguez-Gironés, and Dr. Xiaojian Zhu, who are scientists and explorers, thank you all for your review and comments on the draft of this book.

Last but not least, I extend my heartfelt appreciation to all the Expedition Cruises that have granted me the privilege of exploring Antarctica and provided me with the breathtaking experiences that fueled the content of this book.

Preface

Antarctica, one of the most remote and inaccessible places on earth, is the southernmost of all continents, the place where the lowest temperatures on earth have been measured (about -90℃/-130℉), where the biggest icebergs and glaciers have been found, and where the South Pole itself is located. It is an ice-covered region where you can meet extreme weather conditions, but also some of the most breathtaking landscapes and incredible forms of life.

This region of the world has been beyond human touch since its formation due to its remote geographical location, the strong current of the rough Southern Ocean around it, and the extreme weather and low temperatures, until just about 200 years ago. From the end of 1700 and beginning of the 19th century was the start of the "golden age of Antarctic exploration" in which many heroic expeditions failed and others succeeded in the task of discovering and exploring the far icy withe continent.

Nowadays, the advance of technology allows us to reach the Antarctic continent much more safely, for scientific research, expedition tourism, educational programs, etc. Expedition tourism plays a huge role in educating and inspiring people all around the world about protecting the planet that we all live on, together with establishing strict international protocols and guidelines for visitors through the International Association of Antarctic Tour Operators (IAATO).

As an Artist with a Ph.D. in Zoology I am very proud of working as an Expedition Guide in Antarctica since 2017, and together with other great specialists in Marine Biology, Ornithology, Geology, History, Photography, Outdoor Activities, etc... being part of the Expedition Team onboard Expedition cruise ships.

The more I work in Antarctica, the more I am inspired to share my experiences with a wider variety of people. And I believe it's a perfect way to record and express my feelings and stories through my paintings!

I hope this book brings you to travel with your mind, breathe the fresh air of Antarctica, and enjoy the beauty of this extreme region with my watercolor adventures!

Introduction

Watercolor Adventures in Antarctica is mainly an art book created to share with you some of the landscapes and wildlife I've seen during my guiding adventures in the frozen continent. The short stories and facts next to my paintings are easy to read and will try to give you a better understanding of the animals and places in a relaxed way.

All the images in this book were hand-painted by me with brushes, watercolors, and some colored pencils.

The adventures start with the first chapter about the lovely Penguins: What do they look like? And how do they live in Antarctica? I painted portraits of the eight species, together with some interesting behaviors.

The second chapter shows you seven interesting Landing Sites: Each landing site has unique scenery according to its geographical and biological environment. The landscape paintings and short descriptions illustrate those special moments for me.

Chapter three introduces more incredible wildlife: You will see more paintings and descriptions of Seabirds, Seals, and Whales. Painting these animals is a great way to understand their characteristics and personalities. After that, it is hard not to fall in love with them! You should have a try!

The information for the birds is from www.birdsoftheworld.com; for the marine mammals is from *Whales, Dolphins, and Seals: A Field Guide to the Marine Mammals of the World*; and for the landing sites is from www.IAATO.org and www.bas.ac.uk.

This book is not aiming to be a scientific field guidebook covering all the aspects of Antarctica. There are many other good and interesting books available for that purpose.

As long as I could bring you new thoughts, or take you travelling a little bit to Antarctica with your imagination, I will accomplish the purpose of this book.

Thanks for giving me a little space in your readings, big penguin hugs!
Jiazi Liu

I. PENGUINS

The world-famous ambassadors of Antarctica

I still remember the excitement when I stayed close to penguin colonies in Antarctica for the first time! That should be a highlight moment in my whole life!

I believe that everybody who comes to Antarctica will fall in love with these cute creatures!

Penguins and Antarctica are always connected. However, only a few penguin species live in Antarctica. I have seen eight different penguins in the Antarctic/Subantarctic regions:

Two Great Penguins: Emperor Penguin and King Penguin;

Three Brush-tailed Penguins: Gentoo Penguin, Chinstrap Penguin, and Adélie Penguin

Two Crested Penguins: Macaroni Penguin and Southern Rockhopper Penguin

One Banded Penguin: Magellanic Penguin

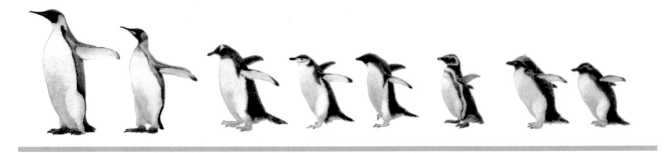

Emperor King Gentoo Chinstrap Adélie Magellanic Macaroni Southern
 Rockhopper

The emperor penguin is the largest penguin, up to 130cm tall. Emperor penguins are restricted to fast and pack-ice. They are not easy to see when we sail around the Antarctic Peninsula. Only very few might be found on floating ice in random locations. It could be years of guiding on Antarctic trips without encountering a single emperor penguin.

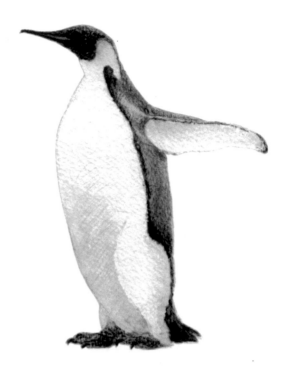

Emperor Penguin

Aptenodytes forsteri
- Restricted to Antarctica, 66°– 78°S
- 112 – 115 cm (3'8" – 3'9")
- 19 – 46 kg (41.9 – 101.4 lb.)
- Chicks have black and white heads and gray bodies

The king penguins look similar to the emperor penguins but stay in warmer Antarctic/Subantarctic regions. We probably will never have the problem of seeing them together and getting confused. Another critical point to identify the king penguin is the chicks! The nesting cycle of a king penguin occupies almost a year. So, we will always see some chicks! They are brown the whole body and look like kiwis!

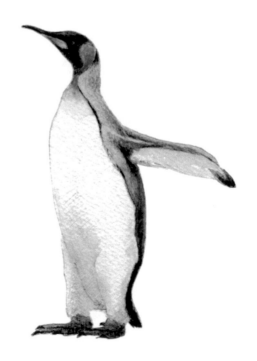

King Penguin

Aptenodytes patagonicus
- Low latitudes of Antarctic/Subantarctic
- 94 – 95 cm (about 3'1")
- 9 – 15 kg (19.8 – 33.1 lb.)
- Chicks are brown and look like kiwis

The Magellanic penguin is a cute banded penguin living in the Subantarctic area. They dig burrows for breeding. It is the only one that starts life a bit "underground" among all these eight species.

Magellanic Penguin
Spheniscus Magellanicus
- Subantarctic
- 70 – 76 cm (2'4" – 2'6")
- 2.3 – 7.8 kg (5.1 – 17.2 lb.)

The southern rockhoppers are the smallest crested penguins, with sparser not meet on the forehead). They also breed in the Subantarctic region and often mix with albatrosses. Worthy of the name, it jumps more than walks in their rocky breeding grounds.

sparser thin lemon-yellow crests do not meet on forehead

red bill without fleshy area at the base

Southern Rockhopper Penguin
Eudyptes chrysocome
- Subantarctic
- 51 – 62 cm (1'8" – 2')
- 2 – 3.8 kg (4.4 – 8.4 lb.)
- The smallest crested penguin

Macaroni penguins also live and breed in Antarctic/Subantarctic areas. They are bigger and more robust than the southern rock hoppers. They have thicker yellow crests that meet on the forehead and a pink fleshy site at the base of the bill. I wonder if macaroni has some problems with species self-awareness because sometimes, they mix with other penguin species randomly. We often see a few macaronis hiding quietly among the southern rockhoppers. And even one macaroni stays in chinstrap penguin colonies for many years on Half Moon Island! Its performance art makes it very famous!

pink fleshy area at the base of the bill

yellow crests meet on the forehead

Macaroni Penguin
Eudyptes Chrysolophus
- Antarctic/Subantarctic
- 70 – 71 cm (about 2'4")
- 3.1 – 6.6 kg (6.8 – 14.6 lb.)

The Brush-tailed Penguins are a truly Antarctic group and the most common to see around the South Shetland Islands and the Antarctic Peninsula. All of them are black and white with pinky feet and rather long tails.

long orange bill dark culmen and tip white patch

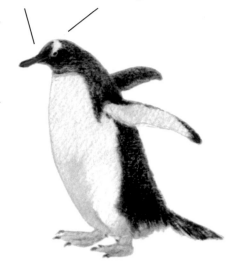

The Gentoo penguin is the biggest among these three. It is the third biggest penguin species after those two great penguins. Other than that, it is the fastest swimmer among all the penguins! 36 km/h (22.4 mph)! They look like bullets when swimming underwater! This big, orange-bill and orange-feet penguin is very difficult to ignore.

Gentoo Penguin

Pygoscelis papua
- Antarctic/Subantarctic
- 76 – 81 cm (2'6" – 2'8")
- 4.5 – 8.5 kg (9.9 – 18.7 lb.)
- Fastest swimmer among penguins 36km/h

Chinstrap penguin is the smiling penguin! Especially when they walk towards us or look at us from the front!

chinstrap

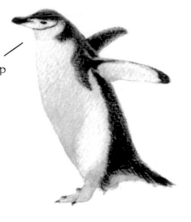

Chinstrap Penguin

Pygoscelis antarcticus
- Antarctic/Subantarctic
- 68 – 77 cm (2'3" – 2'6")
- 3.2 – 5.3 kg (7.1 – 11.7 lb.)

Adélie Penguin has cute white eye rings. French Expedition Jules Dumont d'Urville named it in 1840 with his wife's name. Largely restricted to Antarctica, the Adélie penguins are closely associated with sea ice, and are food specialists mainly feeding on krill.

white eye ring

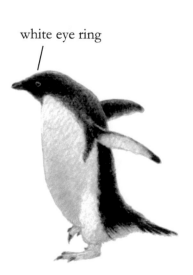

Adélie Penguin

Pygoscelis adeliae
- Antarctic
- 70 – 71 cm (about 2'4")
- 3.8 – 8.2 kg (8.4 – 18.1 lb.)
- Food specialist, foraging mainly on krill
- Molt on ice floes rather than in the breeding colonies

The three brush-tailed penguins not only look similar and share similar habitats but behave similarly in many aspects.

Each year they return to the same site where they were born to breed. They need to build a nest in a place with almost no soft or warm materials like vegetation. So, they use the best that they can have in

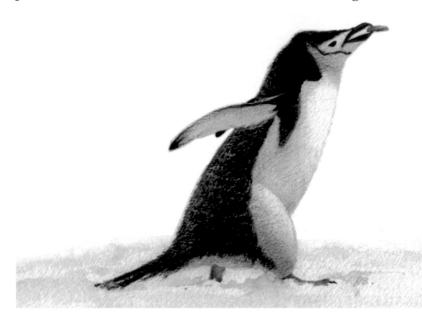

Antarctica: stones. Sometimes they even bring stones from the far away beach. It is a lot of effort for these little penguins to collect this precious construction material. And they must always keep an eye on the neighbors because of the frequent thefts. To survive in the stony home, penguin eggs have thick shells.

Mating happens in the early breeding season. Penguins are monogamous, but the pair band's strength varies according to species and locality. Penguin mating is an impressive maneuver that requires balance,

compromise, and of course, love. The mating season might be the best time to tell the genders of penguins! Those bearing muddy footprints on their backs are probably ladies!

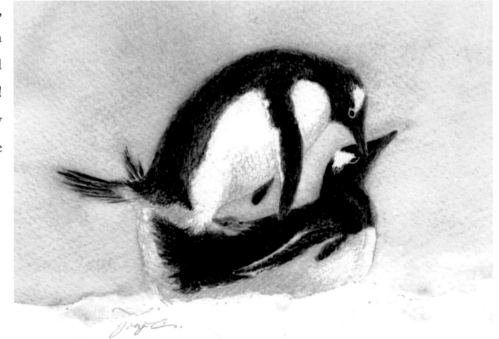

Usually, The Brush-tailed penguins lay two eggs, and both parents take turns incubating the eggs for about 4-6 weeks. In Antarctica, keeping warm is essential, even in the summer. The penguin parents will lose some of the feathers at the bottom of their bellies to warm their eggs. It is called the brood patch.

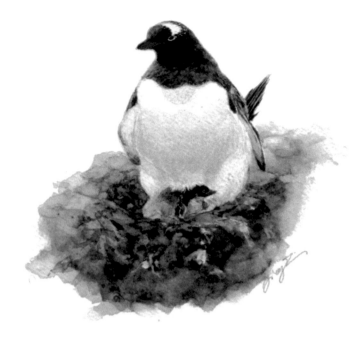

When chicks grow bigger, it becomes difficult for one parent each time to feed both chicks. More likely, Mommy and Daddy both have to go to bring food back. To be safer, from 2-5 weeks old, when they are sometimes left alone, chicks gather together in crèche, with a few adults guarding around. The chicks will fledge at about two months old and become independent after fledging. Watching a group of naive playful chicks with various hairstyles walking in front of us is a great entertainment!

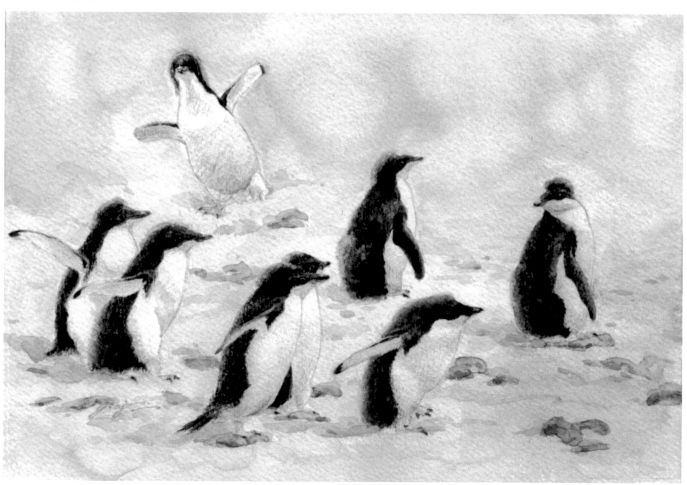

A group of fledging Adélie penguin chicks. They are shedding off the chocolate down and changing into adult feathers.

At colony, penguins are very noisy. There is pretty much information in their ecstatic displays. When a penguin is calling in its unique voice and tone, it might be looking for love, claiming territory, or communicating with its partner or chicks.

Finally, it is time for the adults to change their coats after breeding. They molt every year. Those who fail to breed due to weather or other reasons might start to molt earlier. These 2-3 weeks is the most vulnerable time for the penguins because they have to stay away from water without feeding.

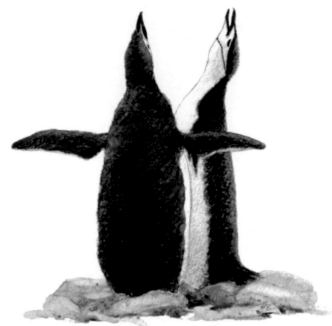

When visiting penguins, we always try to reduce our impact on them. We maintain at least 5 meters (16'5") distance from them. We keep quiet or talk in a low voice when we are close to them. We give the right of way to penguins and never stay in their way. Penguin walk frequently between their nesting ground to the sea for feeding. Therefore, gradually they create thoroughfares in the snow. We need to be very careful not to step on top of those "penguin highways." And we must flatten deep holes in the snow after us to prevent them from trapping the penguins.

II. LANDING SITES

Stepping on a frozen world

Our voyages usually start at the tip of South America: Punta Arenas of Chile or Ushuaia of Argentina.

The first challenge we meet is the Drake Passage! It is famous for stormy waves! The captain will figure out a plan to go as smoothly and safely as possible. If lucky, instead of the "Drake Shake," we might experience the "Drake Lake".

The sudden drop in temperature in seawater indicates that we are in Antarctica!

We sail to the South Shetland Islands and the Antarctic Peninsula the following days.

In this Chapter, I will share some of my best memories of seven popular landing sites.

The colored circles in the map below, show the areas where these Landing sites are located.

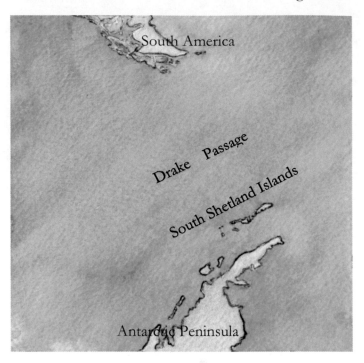

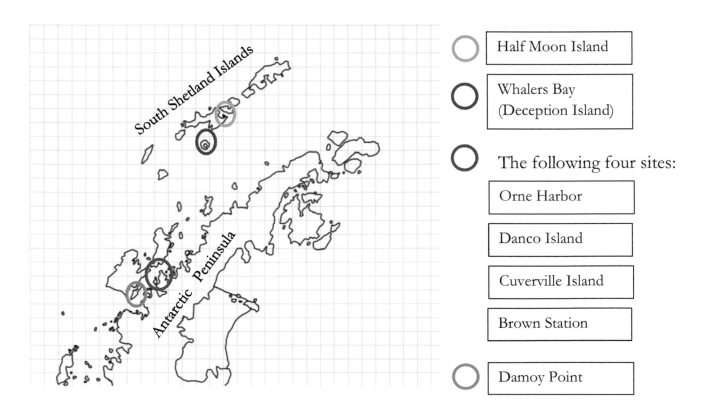

○ Half Moon Island

○ Whalers Bay
(Deception Island)

○ The following four sites:

Orne Harbor

Danco Island

Cuverville Island

Brown Station

○ Damoy Point

Half Moon Island

Half Moon Island
- Location: 62.590°S, 59.920°W
- Wildlife:
 - Seabird: Chinstrap Penguin, Gentoo Penguin, Antarctic Tern, Blue-eyed Shag, Kelp Gull, Skua, Snowy Sheathbill, and Wilson's Storm Petrel
 - Seal: Elephant Seal, Weddell Seal, and Antarctic Fur Seal
- Plant: Moss and Lichens
- Other:
 - Mountains and glaciers of Livingstone Island
 - Argentina Antarctic summer station: Cámara

Half Moon Island is named according to its shape. This 2km-long (1.24 mi) island is between Greenwich Island and Livingston Island, in the South Shetland Islands.

Half Moon Island was my first landing in Antarctica ever! It was early November; thick snow covered almost everything. The landing site was so pure and peaceful! There was a purplish warm, cloudy sky above me, and gentoo and chinstrap penguins close to my feet! It matched with all my imagination perfectly about Antarctica!

In the following years, I have been on Half Moon Island many times. Even though it looks different due to the weather, the snow, the ice, and the penguins, the fresh memory of the first step on the land of Antarctica comes to me every single time!

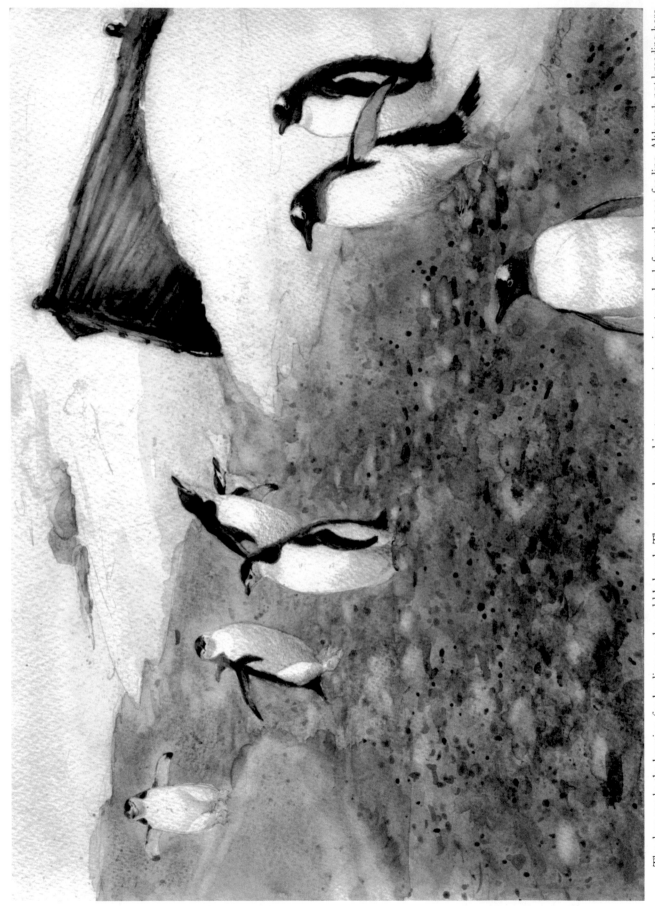

The dory marks the location for landing on the pebble beach. There are always chinstrap penguins going to or back from the sea feeding. Although not breeding here, some gentoo penguins visit this area frequently. Sometimes seals haul out here as well. The penguins can get very curious about the boat.

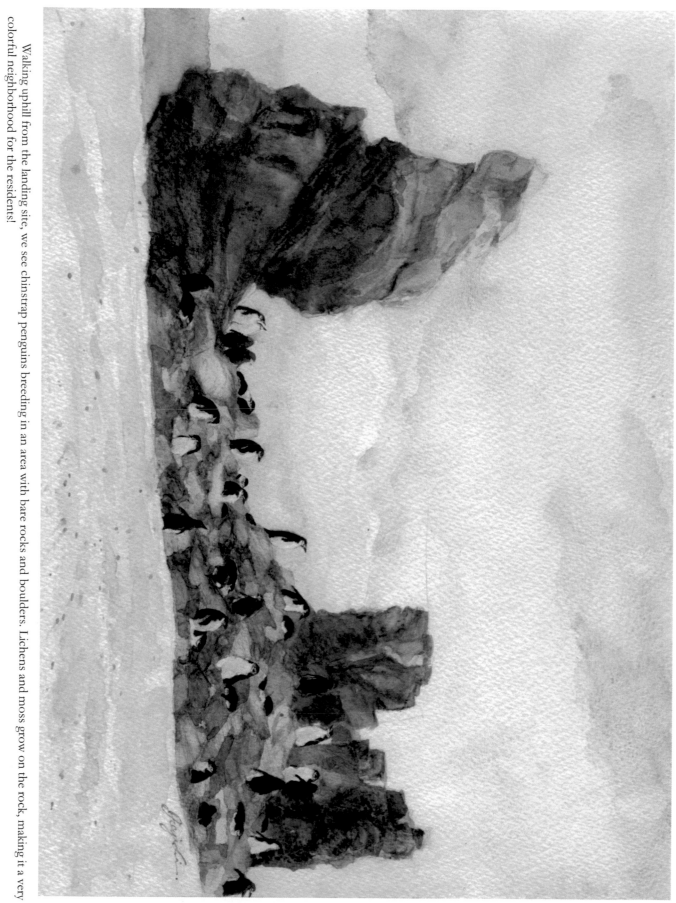

Walking uphill from the landing site, we see chinstrap penguins breeding in an area with bare rocks and boulders. Lichens and moss grow on the rock, making it a very colorful neighborhood for the residents!

13

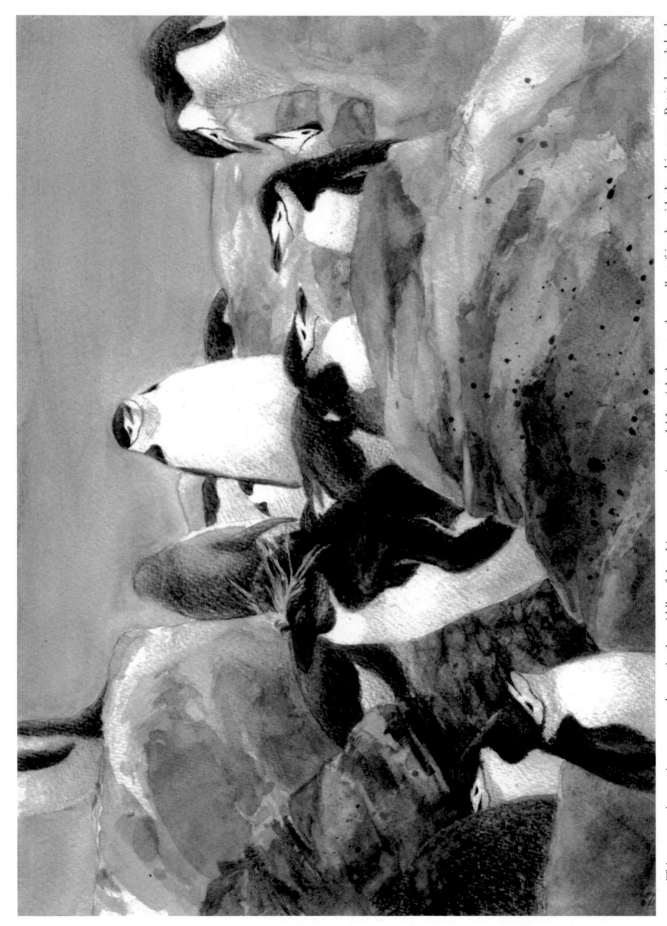

This macaroni penguin returns and stays in the middle of the chinstrap penguins yearly! It might have made excellent friends with the chinstraps. But it doesn't look like it has ever made a family with a chinstrap!

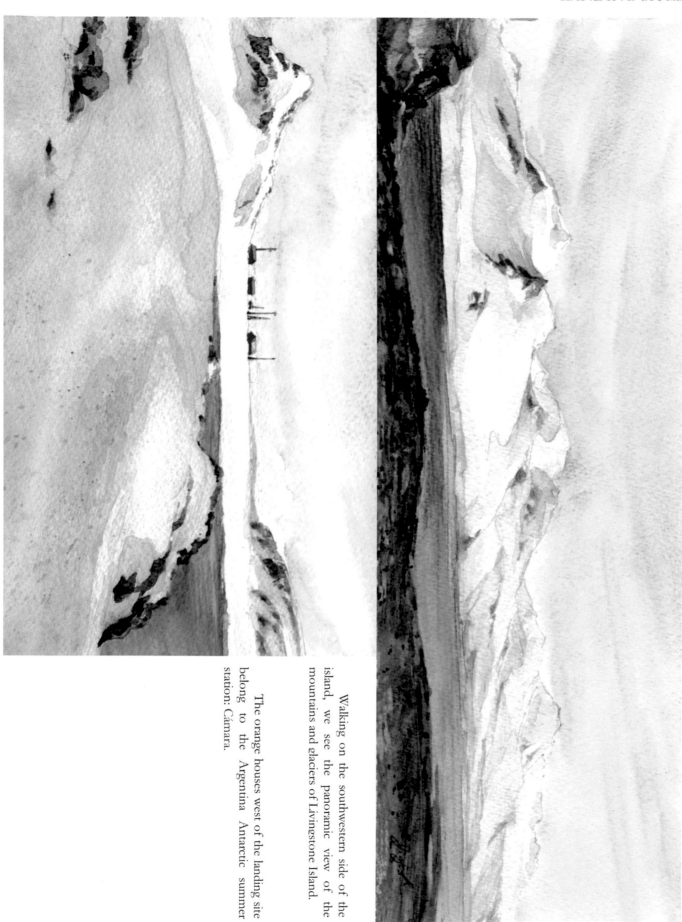

Walking on the southwestern side of the island, we see the panoramic view of the mountains and glaciers of Livingstone Island.

The orange houses west of the landing site belong to the Argentina Antarctic summer station: Cámara.

15

Orne Harbor

Orne Harbor
- Location: 64.633°S, 62.550°W
- Wildlife:
 - Seabird: Chinstrap Penguin, Antarctic Tern, Blue-eyed Shag, Kelp Gull, Skua, Snowy Sheathbill, Cape Petrel, Snow Petrel, and Wilson's Storm Petrel
 - Seal: Leopard Seal, Weddell Seal, and Antarctic Fur Seal
- Plant: Moss and Lichens
- Other:
 - Glaciers
 - Spigot Peak
 - Overlook of the Errera Channel, Gerlache Strait, Anvers and Brabant Islands

Surrounded by glaciers and steep peaks, Orne Harbor lies on the west coast of Graham Land on the Antarctic Peninsula.

The name Orne Harbor might be from Norwegian Whalers.

Orne Harbor is one of the most challenging landings! The landing site has limited level ground. To reach the viewpoint and see the chinstrap penguins, we need to walk up to a saddle about 100 m (328') above the sea! To make it easier and safe, we make the route zigzaggingly. Because the snow slop is very steep, the road is narrow and slippery. Usually, we have to shovel some steps and small resting platforms wherever necessary. It is most of the time a sweating day!

Once there, it is worth all the effort! Smiling chinstrap penguins are nesting all along the ridge! Overlook of the Errera Channel, Gerlache Strait, Anvers and Brabant Islands! Sometimes there are groups of whales swimming and feeding in the water!

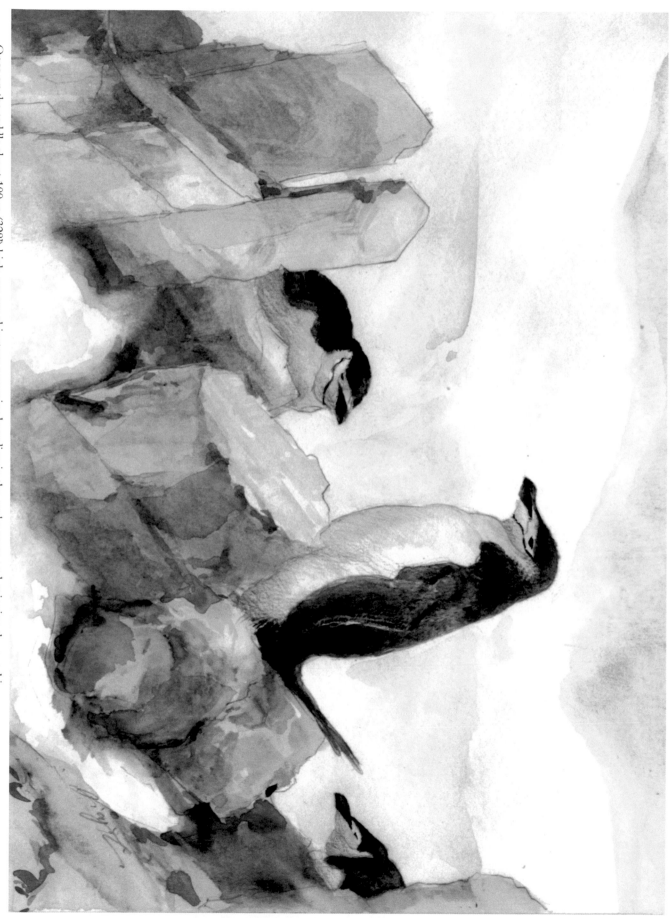

Once on the saddle about 100 m (328') high, we see chinstrap penguins breeding in the rocky areas and enjoying the sunshine.

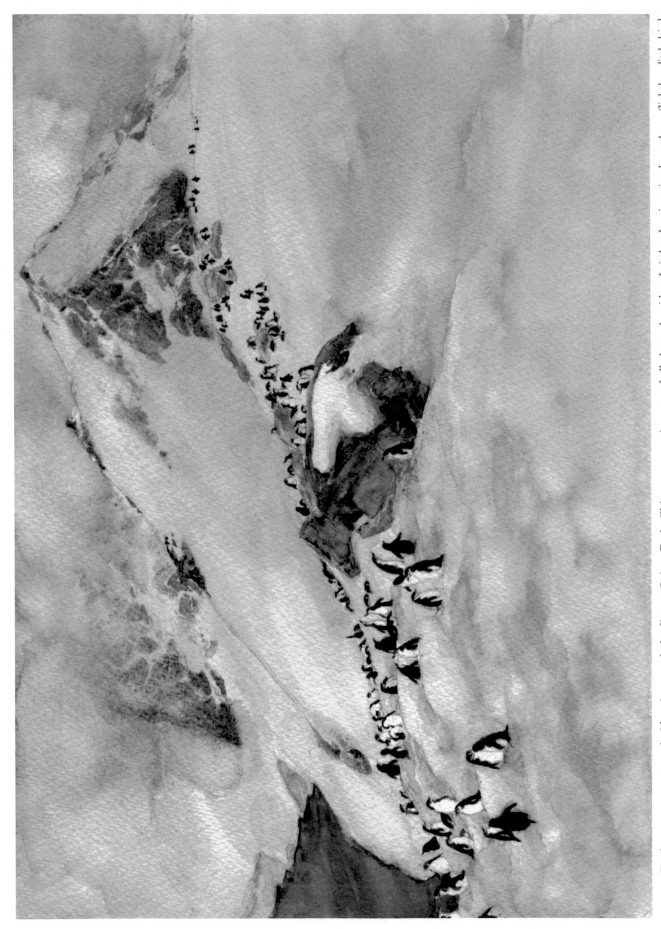

Furthermore, a steep rock ridge rises north, leading to Spigot Peak. Chinstrap penguins spread all along the ridge. It is hard to imagine how these flightless little birds with short legs make their way up high!

Danco Island

Danco Island
- Location: 64.733°S, 62.600°W
- Wildlife:
 - Seabird: Gentoo Penguin, Antarctic Tern, Blue-eyed Shag, Kelp Gull, Skua, and Snowy Sheathbill
 - Seal: Crabeater Seal and Weddell Seal
- Plant: Lichens and Snow Algae in the late summer
- Other:
 - Glaciers
 - The Errera Channel

Danco Island is about 2 km (1.24 mi) long and lies in the southern part of the Errera Channel, on the west coast of Graham Land, Antarctic Peninsula.

The island got its name after Emile Danco (1869-1898), a Belgian geophysicist who sailed and died on board Belgica in Antarctica.

Danco Island is an important breeding site for gentoo penguins. Along the way to the top of the hill, wherever there is a snow-free area, there are gentoo penguins nesting. The heavy traffic between breeding grounds and the ocean makes a web of the penguin highway system in the snow. We must stop and give way to penguins frequently in this area.

I enjoy a lot the landscape around Danco Island! Together with the subtle colors of the sky and clouds, the glaciers, mountains, and the Errera Channel present a spectacular view!

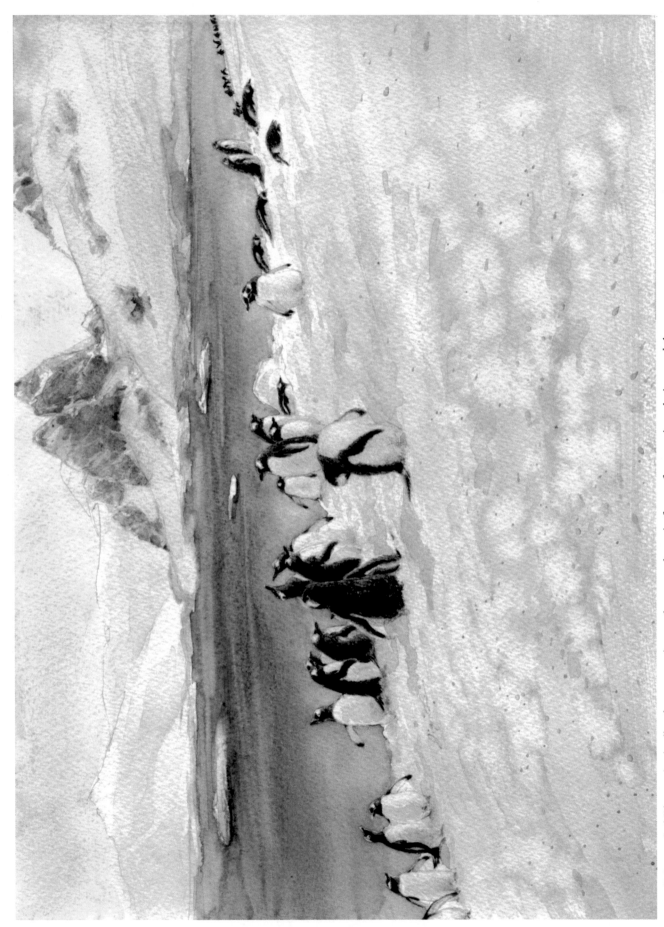

It is a typical "Antarctic view" to have penguins on the snow slopes in front of mountains, glaciers, and the sea.

How they walk might be one reason penguins are sometimes not considered birds. And every penguin has its walking style!

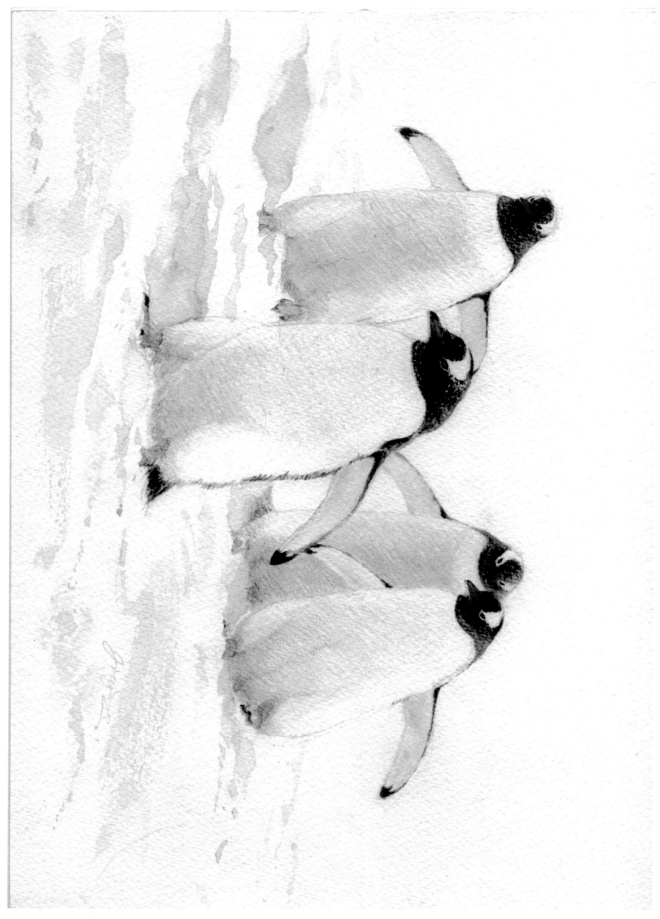

Cuverville Island

Cuverville Island
- Location: 64.683°S, 62.633°W
- Wildlife:
 - Seabird: Gentoo Penguin, Antarctic Tern, Blue-eyed Shag, Kelp Gull, Skua, Snowy Sheathbill, Cape Petrel, Snow Petrel, and Wilson's Storm Petrel
 - Seal: Leopard Seal, Weddell Seal, and Antarctic Fur Seal
- Plant: Antarctic Hair Grass, Antarctic Pearlwort, Moss, and Lichens
- Other:
 - Glaciers and Floating Ice
 - Whaling artifacts like scattered whale bones and whalers' dam from the early 20th century

Cuverville Island is about 2 km (1.24 mi) by 2.5 km (1.55 mi) and dome-shaped, lying north of the Errera Channel, between the northern part of Rongé Island and the west coast of Graham Land, Antarctic Peninsula.

It was named during the Belgian Antarctic Expedition (1897-1899) for a vice admiral of the French Navy: Jules de Cuverville (1834-1912).

Approaching the landing site in a small boat is an adventure! It requires skillful and careful driving to pass through the maze of floating ice. Once on the cobble beach, within a short walking distance, there are gentoo penguins breeding. It is also exciting to see the penguins porpoising and swinging in the water!

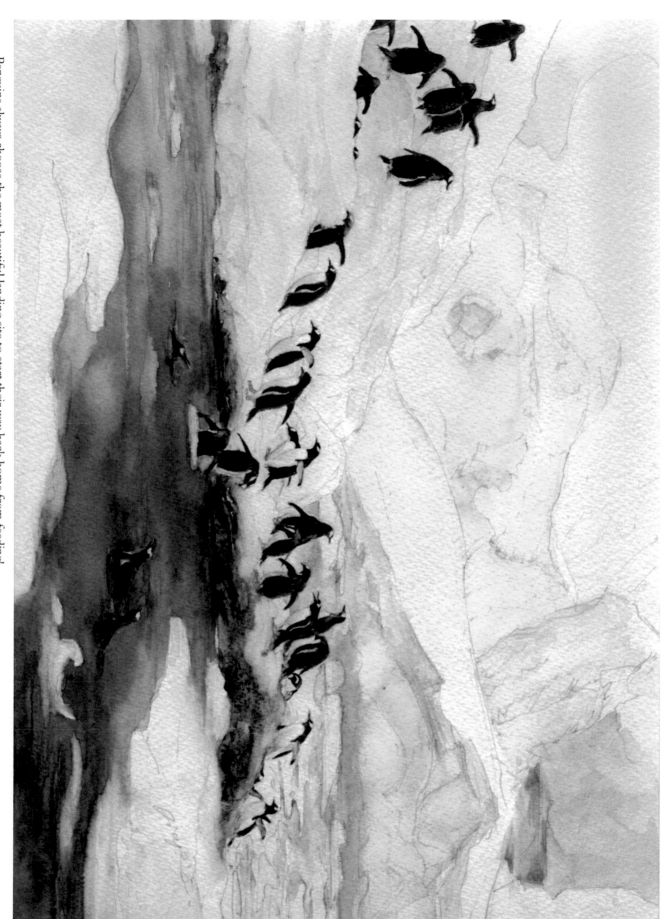

Penguins always choose the most beautiful landing site to start their way back home from feeding!

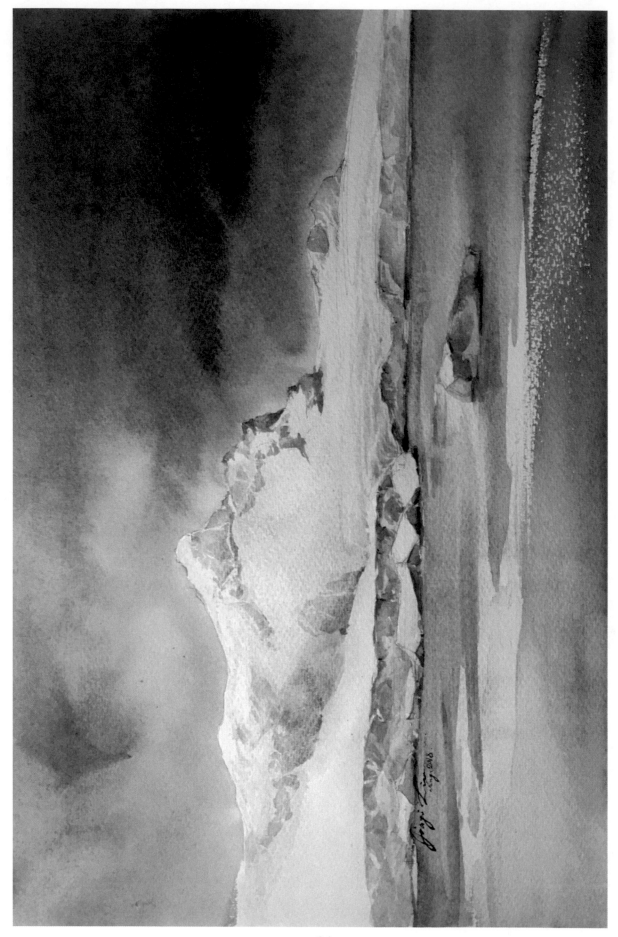

To the west of Cuverville Island is Rongé Island covered with snow and ice. On a heavy cloudy but calm day, it looks extraordinarily solemn!

Brown Station

Brown Station
- Location: 64.883°S, 62.883°W Sanaviron Peninsula, Gerlache Strait
- Wildlife:
 - Seabird: Gentoo Penguin, Antarctic Tern, Blue-eyed Shag, Kelp Gull, Skua, Snowy Sheathbill, Cape Petrel, and Wilson's Storm Petrel
 - Seal: Crabeater Seal, Leopard Seal, and Weddell Seal,
- Plant: Antarctic Hair Grass, Moss, and Lichens
- Other:
 - Glaciers
 - Scientific Station Buildings

Brown Station is an Argentine scientific research station. It is on Sanavirón Peninsula in Graham Land, Antarctic Peninsula.

Its name is from Admiral William Brown, who was the father of the Argentine Navy.

When landing at the station's dock, a few steps further on land, we are among the gentoo penguins. We have to be very careful to walk through, avoiding close vicinity. After the penguins, it is nice to visit the Ortiz Shelter and walk uphill to a viewpoint about 90 meters (about 300') above the sea, where it reveals magnificent glaciers and mountains.

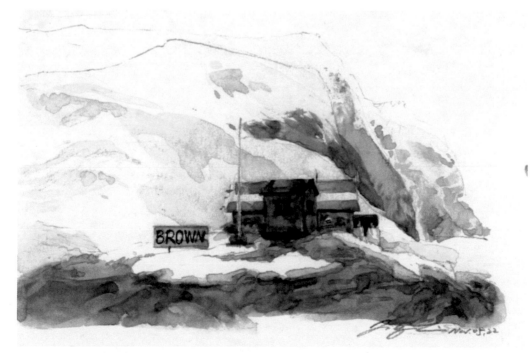

Orange stands out in this frozen continent!

25

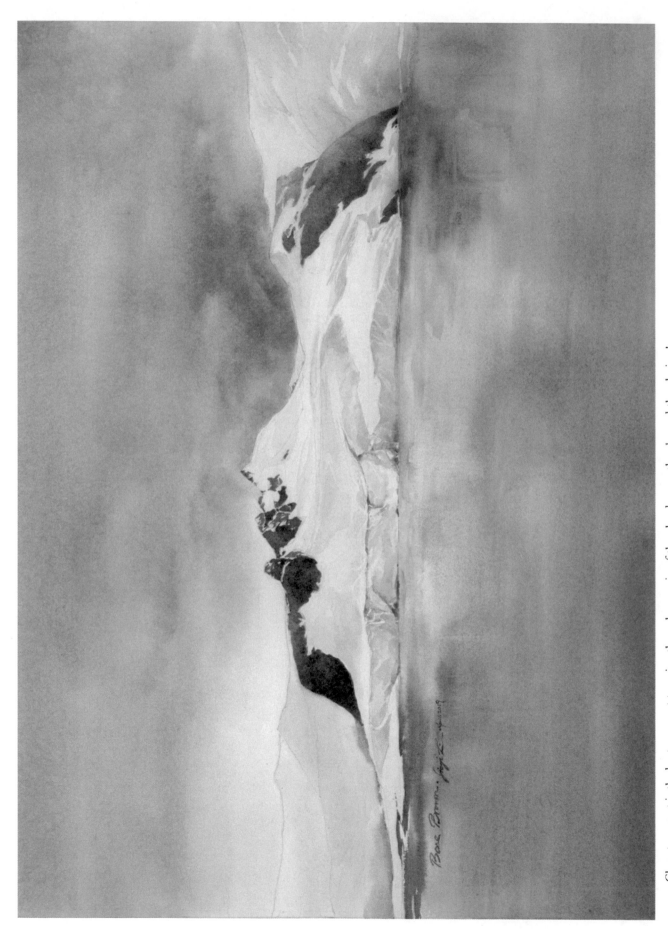

Close to sunset is the best moment to enjoy the color magic of the clouds over the sky and the glaciers!

Damoy Point

Damoy Point
- Location: 64.817°S, 63.517°W Dorian Bay, Wiencke Island
- Wildlife:
 - Seabird: Gentoo Penguin, Antarctic Tern, Kelp Gull, and Skua
 - Seal: Crabeater Seal, Leopard Seal, Weddell Seal, and maybe Antarctic Fur Seal in the late summer
- Plant: Moss and Lichens
- Other:
 - British hut and Argentine hut
 - Mountains and Glaciers

Damoy point is on the west of Wiencke Island in the Palmer Archipelago. It is the northern entry point to the harbor of Port Lockroy.

The French Antarctic Expedition (1903-1905) discovered it and named it.

Damoy point is a place of various interests: the gentoo penguins and other wildlife, the stunning landscape of Wiencke Island and Dorian Bay, the historic British hut, and the Argentine emergency hut.

One of the highlights is the Turquoise British Hut. It is a Historic Site and Monument (No.84). The British Antarctic Survey (BAS) established it in November 1975. Until 1993, BAS used the Damoy hut as a transit station for their staff and supplies when the sea ice packed the way to Rothera Research Station for the ship during the winter. There is a skiway on the Glacier above the hut for the flights.

The hut now is like a little museum. Before entering, we must clean the snow on the boots to protect the wooden floor. Inside the hut, it keeps the way it was 30 years ago: the bedroom, the kitchen, and the dining table. There is also a notebook for us to leave our notes and comments.

With snowshoes, we can go to the top of the glacier to overlook the famous Port Lockroy, with the breathtaking scenery of glaciers and mountain ridges behind it. There, British Station A has turned into a museum. Every Antarctic summer, four staff from the UK Antarctic Heritage Trust will take care of the museum and run the southernmost post office! It is limited opportunity to land in Port Lockroy, but sometimes it is possible to invite the staff to come on board for a while. We enjoy their stories and souvenirs, while they can take our mail and have them stamped in Antarctica! I enjoy that three months or longer when my friends and family get surprised and excited to receive greetings from the frozen continent!

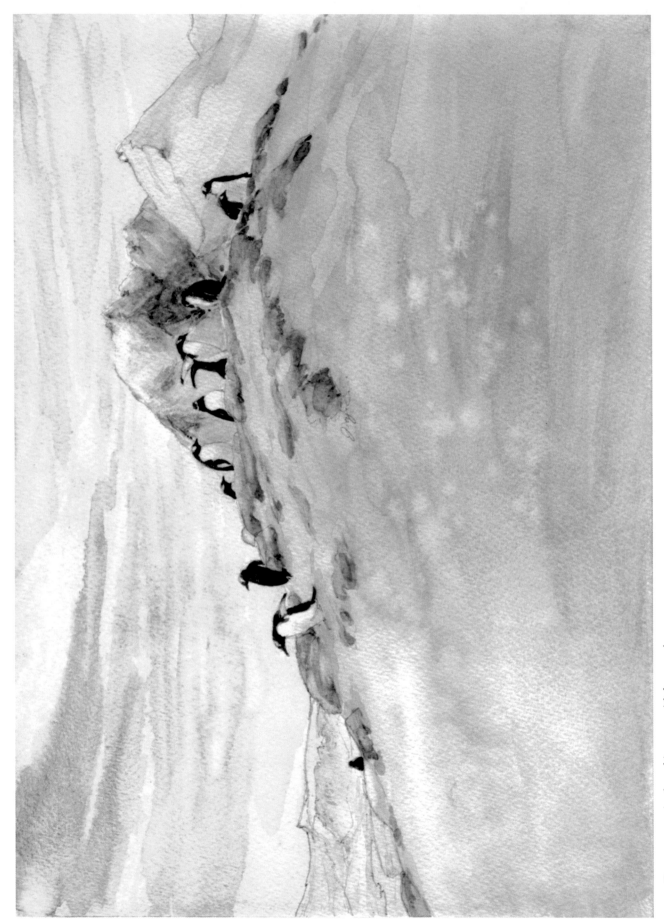

Gentoo penguins breed in areas with bare rocks.

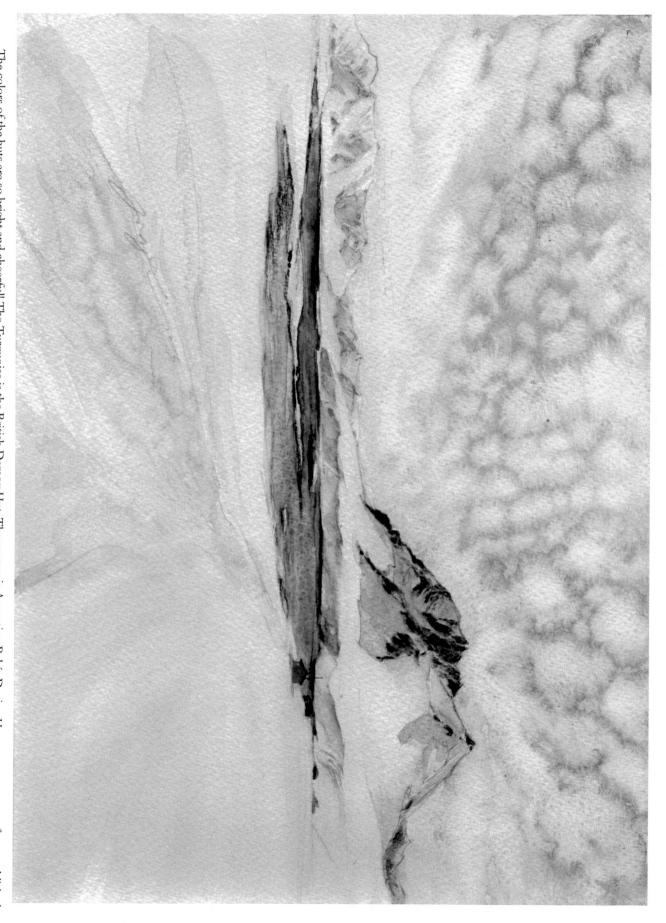

The colors of the huts are so bright and cheerful! The Turquoise is the British Damoy Hut. The orange is Argentine Bahía Dorian Hut, an emergency refuge established on February 23 0f 1953, by the Argentine Navy.

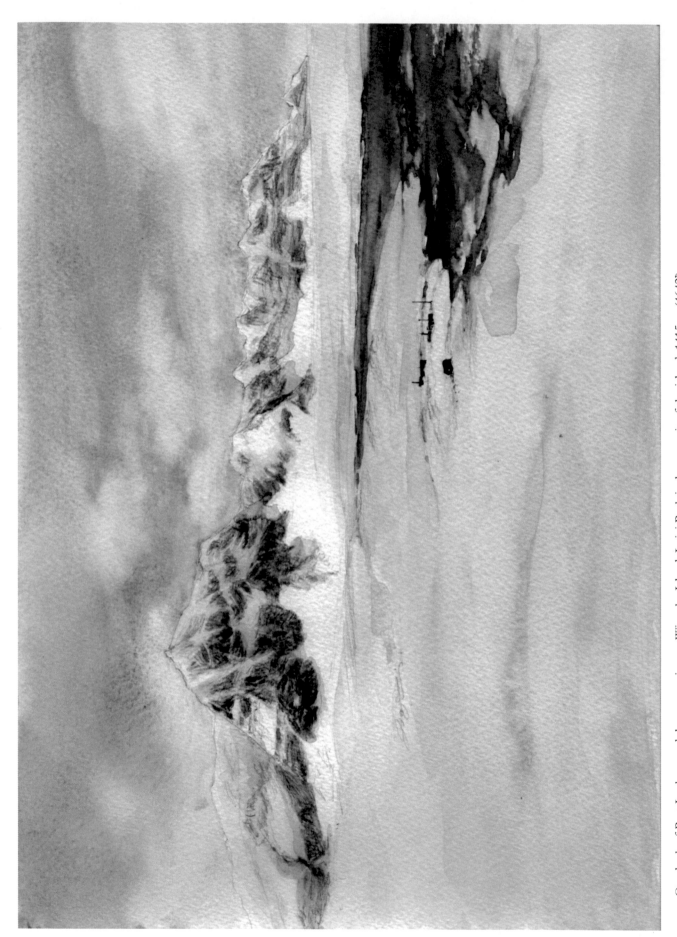

Overlook of Port Lockrov and the mountains on Wiencke Island. Luigi Peak is the summit of the island. 1415 m (4642').

Whalers Bay (Deception Island)

Deception Island
Deception Island is the caldera of an active volcano. The caldera collapsed about 10,000 years ago after a major eruption. It filled up with water, forming this horse-shoe-shaped island. Ships can sail into it through a narrow channel at Neptune's Bellows. Right after passing through the entrance, Whalers Bay shows up on the northeast.

Whalers Bay
Whalers Bay is an important Historic Site and Monument (No.71), including:
- The remains of the Norwegian Hektor Whaling Station
- The site of the Whaler's Cemetery
- Other whaling remains along the beach
- The abandoned British "Station B": Established in 1944 as a scientific research station on meteorology and geology. It used to be the center for aircraft operation from 1955-1957and 1959-1969. Volcanic eruptions damaged the station in 1967 and 1969, and it was finally abandoned in 1969.
- Location: 62.983°S, 60.567°W Port Foster, Deception Island
- Wildlife:
 - Seabird: Chinstrap Penguin, Gentoo Penguin, Antarctic Tern, Blue-Eyed Shag, Kelp Gull, Skua, Snowy Sheathbill, Cape Petrel, and Wilson's Storm Petrel
 - Seal: Crabeater Seal, Leopard Seal, Weddell Seal, and Antarctic Fur Seal
- Plant: Moss and Lichens
- Other:
 - Volcanic landscapes
 - Historic remains from the whaling time and the scientific station

How exciting it would be sailing with a ship into an active volcano in Antarctica! Not to mention that we must pass the super narrow and shallow entrance "Neptune's Bellows" with accurate and experienced navigation in good weather!

Immediately after the entrance, on the right side, the steaming sandy beach is the landing site of Whalers Bay.

Whalers Bay was discovered and used by sealers from the early 19th century, followed by the whalers in the early 20th century, and got its name there.

As it locates in an active volcano, Whalers Bay looks different from other landing sites in Antarctica. Rather than the continent of snow and ice, it feels maybe more like being on the moon. The water temperature is higher. So, it is a perfect spot to do a polar plunge, and you need to be careful not to burn your fingers! Once I inserted a thermometer a few centimeters into the sand on the beach, it showed over 60℃ (140℉)!

The steam is full of sulfur smell! I can hardly imagine the smell when useless parts processed from whales were abandoned and rotten in this water during the whaling time!

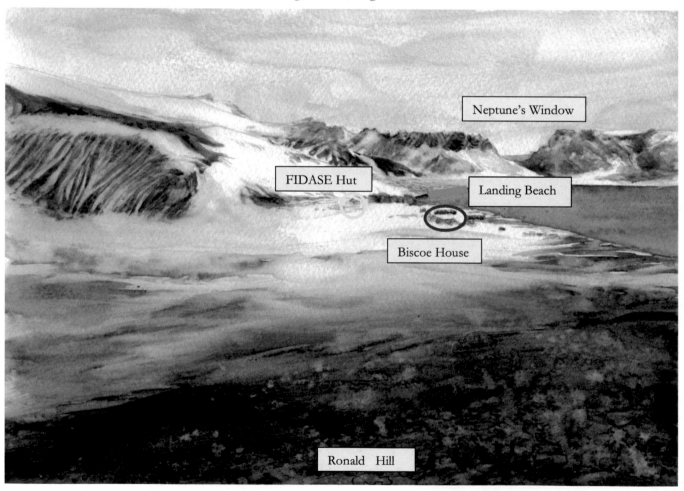

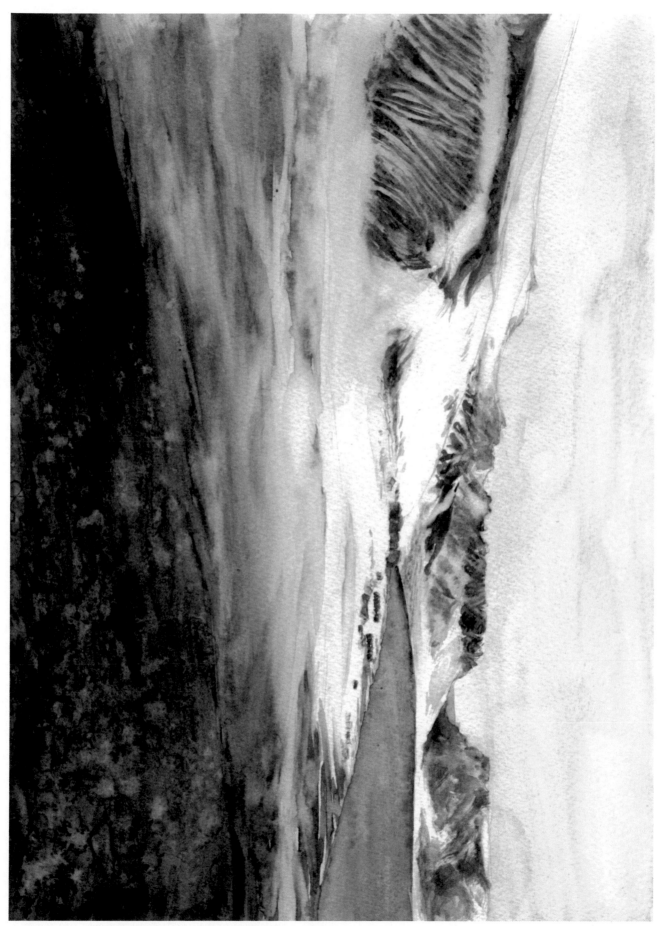

On Ronald Hill, it is the best spot to have a panoramic view of the bay.

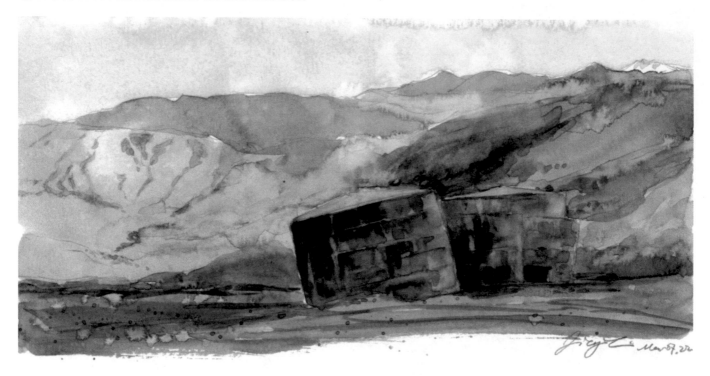

These vast fuel containers from the whaling time have been sinking slowly into the caldera's soft, sandy and ashy terrain.

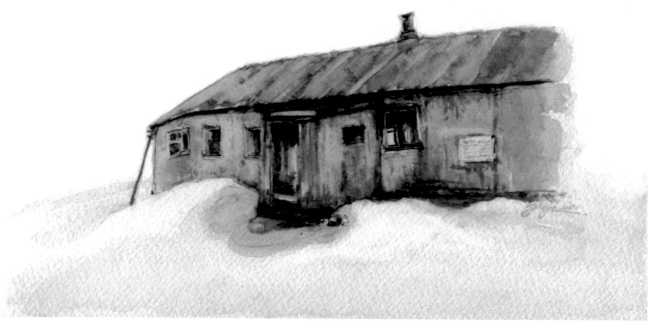

The FIDASE Hut, also known as Hunting Lodge, it was used by members of the Falkland Islands Dependencies Aerial Survey Expedition 1955-1957, hired by Hunting Aerosuveys Ltd. This hut became the property of FIDS after completing the survey.

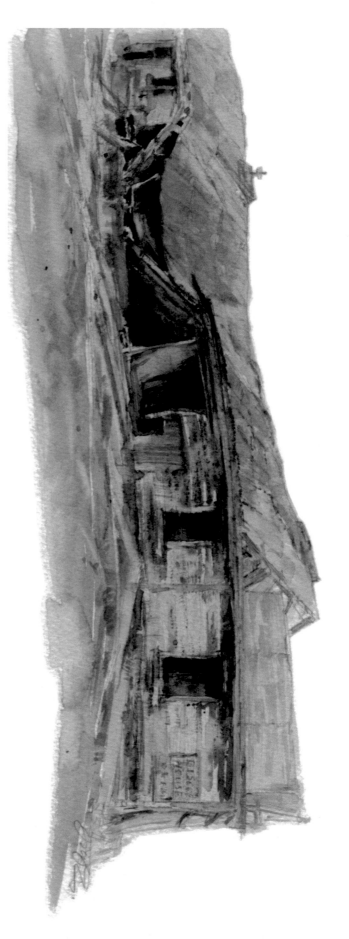

Biscoe House

It functioned as the main accommodation building for British Station B. It was initially the dormitory of the former Norwegian Aktieselskabet Hector whaling station.

35

III. OTHER WILDLIFE

Antarctica is a real paradise for seabirds, seals, and whales

Besides penguins, we will frequently encounter some other seabirds on the landing sites.

Wherever there are penguin colonies, there are skuas! They either stay a little distance away, eyeing the penguin colonies, or circle above, seeking opportunities to steal eggs and chicks. Often the penguin parents have to fight back the skuas bravely with their pointed bills. At the same time, we see successful predation by skuas and some broken egg shells away from the penguin breeding grounds.

Brown skua (Falkland Skua) *Stercorarius antarcticus antarcticus*
Brown skua (Subantarctic skua) *Stercorarius antarcticus lonnbergi*
South Polar skua *Stercorarius maccormicki*
- Antarctic/Subantarctic
- 50 – 64 cm (1'8" – 2'1")
- 0.9 – 2.1 kg (2 – 4.6 lb.)
- Wingspan 126 – 160 cm (4'2" – 5'3")
- Brown Skua (Falkland skua and Subantarctic skua) are bigger, very fierce predators and prey on seabirds such as penguins and small petrels
- South Polar Skua is smaller, mainly feeding on fish, but also taking on eggs, chicks, or weakened penguins
- Alone or in pairs, could be in groups around corpses and carrion
- Dominant scavengers around bodies of very large animals such as pinnipeds and cetaceans
- Very aggressive on the breeding grounds

Another species that lives around penguins is the snowy sheathbill. They are white all over the body. Instead of being elegant, they are shifty skilled thieves. They always wander around their potential food and seek opportunities. Penguins treat them as threats and intruders when they come close to penguin nests. These little white birds are also interested in us and our stuff. Often, we find them testing our landing gears with their bills.

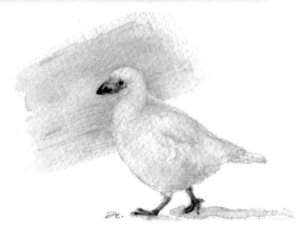

Snowy Sheathbill
Chionis albus
- Antarctic/Subantarctic
- 0.5 – 0.8 kg (1.1 – 1.8 lb.)
- Wingspan 76 - 84 cm (2'6" – 2'9")

- Omnivorous and opportunistic. scavenges around penguin or marine mammal colonies. Mainly interfere with penguins feeding chicks for regurgitated krill, also taking penguin eggs and little chicks
- The only Antarctic breeding birds without webbed feet
- Fearless and extremely inquisitive

The blue-eyed shags sometimes also mix with penguin colonies but are more likely to nest in small colonies on coastal flats and cliffs. But they are easy to find resting on rocks and ice floes. Or, they could be busy picking up materials from both water and land for their nests, such as feathers, algae, small pieces of kelp, or some fiber. Their blue eyes and yellow caruncles above the base of the bill are highly visible. Due to the size and the body color, when it is a bit far away or flying above, sometimes it looks like a penguin. Yes! A Flying Penguin!

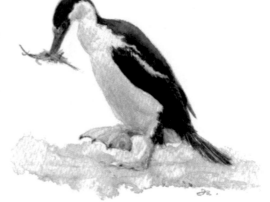

Blue-eyed Shag
Leucocarbo atriceps / Leucocarbo bransfieldensis
- Antarctic/Subantarctic
- 1.7 – 3.0 kg (3.7 – 6.6 lb.)

A bright yellow bill with a red spot and a high contrast black and white body, kelp gulls attract attention quickly, not to mention that they are in flocks and noisy.

Kelp Gull
Larus dominicanus
- Cosmopolitan, but the only Antarctic gull
- 54 – 65 cm (1'9" – 2'2")
- 0.8 – 1.3 kg (1.8 – 2.9 lb.)
- Wingspan 128 – 142 cm (4'2" – 4'8")
- Scavenger, also stealing food, eggs and chicks from other seabirds
- On the coast, drop the molluscs from a height to break the shell and eat
- Very noisy and aggressive when fighting with other gulls over food

Antarctic terns are often seen flying robustly, high, and fast. They hover flight followed by a plunge-dive to catch krill and small fish.

Antarctic Tern
Sterna vittata
- Antarctic/Subantarctic
- 35 – 40 cm (1'2" – 1'4")
- 0.1 – 0.2 kg (0.2 – 0.4 lb.)
- Wingspan 74 - 79 cm (2'5" – 2'7")
- Gregarious, often in flocks
- Very aggressive when defending its nest

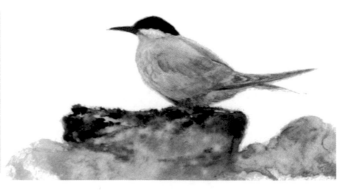

The seals are adorable and funny! Especially for dog lovers like me!

During the Voyages in Antarctica, there are five seals most commonly spotted: the Antarctic Fur Seal, the Crabeater Seal, the Weddell Seal, the Leopard Seal, and the Southern Elephant Seal.

The Antarctic fur seal does not belong to the true seal group because it has tiny ear flaps. They look and behave the most like dogs! Actually, in Chinese, it is called "Sea Dog"!

The males are generally dark brown, with long dark silver-streaked manes; the females are smaller and paler.

Antarctic fur seals have great interest in what humans are doing. They not only raise their body to watch us, but they might approach us rapidly and potentially get a bit more aggressive and bite us! What we do to stop it is hold a stick, point at it and shout, "No!" A similar way of treating a dog! There it will stop, stare at us, think for a few seconds, and usually move away.

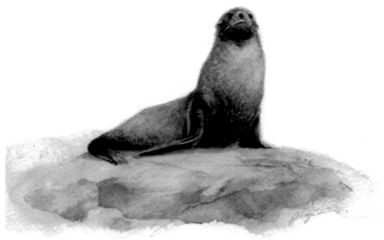

Antarctic Fur Seal

Arctocephalus gazella

- Antarctic
- Male 2 m (6'7"), 110 – 230 kg (243 – 507 lb.)
- Female 1.4 m (4'7"), 22 – 51 kg (49 – 112 lb.)
- Have Ear Flaps
- Enormous rookeries on land but smaller groups at sea. Polygynous
- Feed mainly on krill but also fish, squid, and penguins
- Inquisitive about human activities, sometimes approach humans. It could be aggressive

Among the four true seal species, the face of a crabeater seal is most similar to a dog's face. They have various colors on the body, from pale gray to dark brown.

The name indicates that their diet relay on crabs. However, it is a rumor. They feed mainly on krill, fish, and squid, which hardly has anything to do with crabs.

The crabeater seals are often found on ice while sleeping in groups. They don't have too many reactions to the human approach. But they might raise their heads to estimate the situation and occasionally flee quickly to the water.

Frequently, we can see some scars on crabeater seals. Those are lucky dogs that survived attacks from leopard seals or orcas.

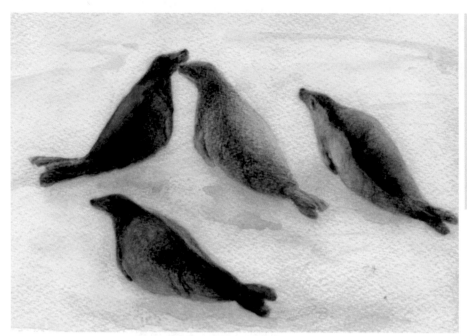

Crabeater Seal

Lobodon carcinophaga
- Antarctic
- 2 – 2.6 m (6'7" – 8'6")
- 180 – 410 kg (397 – 904 lb.)
- Females are slightly larger
- Dog-like face, small dark eyes set well apart
- Diet mainly krill, also fish and squid

Weddell seals are more likely to be seen on land. Their faces look like smiling cats. They are larger,

blueish-black to dark gray, with large pale and dark spots. Weddell seals are asocial. They prefer to sleep alone and, most of the time, ignore the human approach.

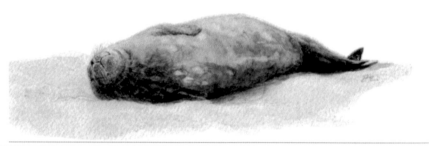

Weddell Seal

Leptonychotes weddellii
- Antarctic
- 2.5 – 3.3 m (8'2" – 11')
- 400 – 600 kg (882 – 1323 lb.)
- Females are larger
- Smiling cat-like face, large dark eyes close-set
- Asocial. They might congregate, breathing holes in the ice. Haul out on land and ice. Mostly seen sleeping on ice but can move rapidly
- Feed mainly on fish, also cephalopods, crustaceans, and penguins
- Very placid and almost docile. Ignore humans and remain sleeping most of the time

Rather than a big cat, the leopard seal looks more like a dinosaur with its big head and powerful jaws. They are blackish-gray, blueish-gray to silver, and also with spots.

Same as a leopard, the leopard seal is a solitary fierce predator. Sometimes we see it resting on land and ice; sometimes, we find it patrolling penguin colonies. When hunting a penguin, the leopard seal will shake the penguin violently until it is inside out, then eat the meat. But it also feeds largely on krill, fish, other seabirds, and sometimes the young of other seals.

Like for leopards, we also use the spot pattern variation to identify leopard seal individuals, but only the pattern on the left side of the face.

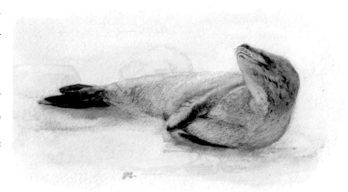

Leopard seal is curious about human activities, especially in the water. It might explore and try to understand more about the boats, the kayaks, or the underwater drones.

Leopard Seal

Hydrurga leptonyx
- Antarctic
- 2.8 – 3.8 m (9'2" – 12'6")
- 300 – 500 kg (661 – 1102 lb.)
- Females are larger
- Big head, dinosaur-like face, and powerful jaws. Broad and long fore flippers
- Feed mainly on krill, fish, seabirds, especially penguins, and sometimes the young of other seals
- Inquisitive about human activities especially in the water

Although much smaller than an elephant, the elephant seal is still massive, especially the males. And they have large round dark eyes.

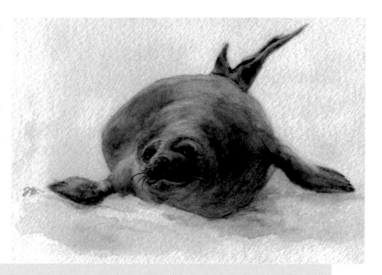

Seeing the elephant seal moving like a giant caterpillar is super funny. And it is not a good idea to be in its way! It will keep moving, ignoring, and rolling on anything in front of it!

Southern Elephant Seal

Mirounga leonina
- Southern Hemisphere
- Bull 4.5 – 6.5 m (14'9" – 21'4"), 3700 kg (8157 lb.)
- Cow 2.5 – 4 m (8'2" – 13'1"), 359 – 800 kg (792 – 1764 lb.)
- Bulls are dark brown and have inflatable proboscis and extensive creasing to the neck. Cows are smaller and lighter colors without proboscis. Round face, large round dark eyes
- Highly social on land. Moving in caterpillar style
- Feed mainly on deep-water fish and cephalopods. Dive deep

Whale watching is always an unforgettable experience!

In the austral summer, humpback whales migrate up to 16,000 km (~10,000 mi) from the tropical waters down to Antarctica for feeding. Although they are baleen whales, generally solitary, in areas with abundant food, they could be very tolerant about others and be in groups.

Sometimes they even work together as a team to make a "bubble net" for fishing! The whales will blow bubbles to circle and trap a school of fish or krill, and then swim upwards with their mouths open to enjoy the feast!

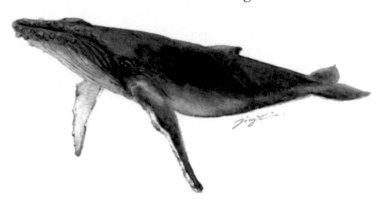

From the ship or the boat, we see the bubble net like a circular area (3-5 meters/10-16') full of little springs in the ocean. Soon, at some point, giant mouths are coming up to the surface almost simultaneously and taking in vast quantities of water.

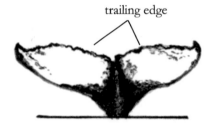

trailing edge

Humpback whales are very playful. They could be blowing and diving around the ship for quite a while. When they dive deeper, they will show the flukes! Fluke is the ID for the humpback whale. Each whale has its unique black-and-white color pattern and trailing edges!

Besides the fluke, humpback whales also like to slap their fore flippers. Their fore flippers are extended up to 1/3 of the body length and can be seen underwater.

If lucky, humpback whales will make a breaching show in the air!

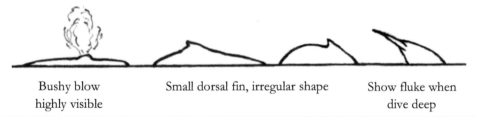

Bushy blow
highly visible

Small dorsal fin, irregular shape

Show fluke when
dive deep

Humpback Whale

Megaptera novaeangliae
- Cosmopolitan
- 11 – 18 m (36'1" – 59'1")
- 24 – 40 ton
- Head and body gray to black. The throat, belly, and sides are pale to white
- Flat rostrum with knobs. Flippers are long, up to 1/3 length of the body. Flippers and fluke often have barnacles infest
- Baleen Whale. Feed mainly on krill and small fish
- Quite active at the surface: breaching, spy hopping, lob-tailing, tail/flipper slapping, and so on
- May be in groups of up to 12 – 15 in feeding areas, conducting "bubble net" fishing sometimes
- Seasonal migration up to 16,000 km (10,000 mi), between feeding grounds in cold waters (austral summer) and breeding grounds in tropical waters

The Antarctic minke whale is small and quiet compared to the humpback whale.

They also migrate from the breeding grounds, principally at 10° - 30°S, to the Antarctic feeding grounds in austral summer. They sometimes travel in packs but are more solitary.

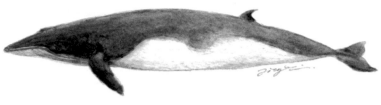

Minke whales usually do not make big shows of flukes, flippers, or breaching. They are shy.

But whenever we see a small whale with a weak blow followed by a sickle-like pointed dorsal fin right after, we know it is a little minke whale!

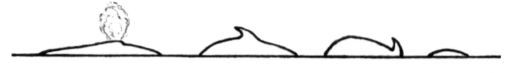

Weak bushy blow Small sickle-like dorsal fin, pointed Dive without fluking

Antarctic Minke Whale

Balaenoptera bonaerensis
- Southern Hemisphere
- 7.2 – 10.7 m (23'7" – 35'1")
- 5.8 – 9.1 ton
- Upper surface gray, grayish-brown
- Small and streamlined body. Pointed snout. Sickle-shaped dorsal fin with a very sharp tip
- Baleen Whale. Feed mainly on krill and small fish
- Relatively quiet, sometimes inquisitive around smaller boats
- Generally solitary, but often travel in packs
- In austral winter, breed principally at 10° - 30°S and migrate to Antarctic feeding grounds in austral summer

Orcas are charming animals!

They are also called "Killer Whales". It is misleading. First of all, instead of whales, they are the largest dolphins. More importantly, they are apex predators but seldom are they interested in killing humans.

Unlike the baleen whales, orcas do not migrate long distances.

Orcas live in families led by their grandma (the eldest female). So, when we see orcas, usually it's a group of 5 or more.

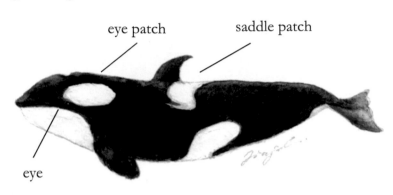

eye patch saddle patch

eye

Their dorsal fins are highly visible! The shape of the dorsal fin and the saddle patch behind it are unique for each individual. We can also tell ladies from gentlemen according

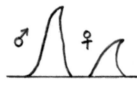

Spy hopping

to the dorsal fins. The males have straight, tall triangle dorsal fins up to 1.8 m (5'11"), while for the ladies their dorsal fins are half tall and curvy.

Orcas are very robust and flexible! They have large rounded flippers functioning as paddles and a strong tail as a propeller to move and turn very fast!

Orcas in Antarctica prey on penguins, or seals and other whales. They communicate and do teamwork as wolves: spy hopping, trapping the prey, chasing the prey, or even making waves to wash down their prey from the ice!

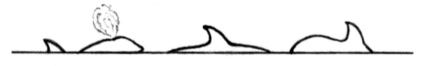

Tall bushy blow Highly visible dorsal fin, Dive without fluking
 various shapes

Orca

Orcinus orca

- Cosmopolitan
- 7 – 9.8 m (23' – 32'2")
- 3.8 – 5.5 ton
- Dark rounded body and a big white eye patch. White throat to the abdomen and rear flanks
- Large round flippers are like paddles. Male has tall, straight triangle dorsal fin up to 1.8m; females' dorsal fins are half the length and curvy. The shape of the dorsal fin and the saddle patch behind the dorsal fin is used for individual identification
- Toothed Whale. Prey on Antarctic toothfish, Penguins, Seals, Minke whales, or other small or weakened whales
- Sociable. Families (2-50 individuals) led by the eldest female live in tight unison
- Developing multiple behaviors and experiences can pass between individuals and generations
- A speeded of 56km/h (35mph) makes them among the fastest marine mammals

About the Author

Jiazi Liu is a Watercolor Artist with a Ph.D. in Zoology currently working as an Expedition Guide on board expedition cruise ships going to Antarctica since 2017.

She started her dream of being an artist at the age of 5. She continues pursuing it after many years of academic training in science. Nowadays, her paintings have been in exhibitions in China and overseas.

Before becoming an Expedition Guide in Polar regions (both the Arctic and Antarctica), Jiazi had spent ten years doing research and conservation programs on wildlife in the Qinghai-Tibet Plateau, west China.

Since 2017 Jiazi has been building her Polar Expedition Guide career with 4 to 8 trips each Antarctic season, positioned as Artist, Biologist, and Science Coordinator on board.

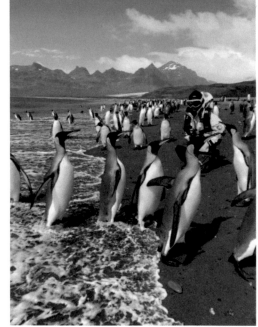

For more Artworks & Stories of Jiazi, please visit:

Facebook Page: www.facebook.com/artist.jz

Instagram: www.instagram.com/artist_jz

Twitter: www.twitter.com/jz_artist

Amazon Author Page:

www.amazon.com/author/jiazi.liu

微信公众号：天涯海角的日常

E-mail: artist.jz.liu@gmail.com

Manufactured by Amazon.ca
Bolton, ON